Art Shows

How to

Find, Enter, and

Win

an Art Show!

Lisa Shea

Content copyright © 2017 by

Lisa Shea / Minerva Webworks LLC

All rights reserved

No part of this book may be reproduced in any form or by any electronic or mechanical means including information storage and retrieval systems, without permission in writing from the author. The only exception is by a reviewer, who may quote short excerpts in a review.

All proceeds from sales of this book support kids-in-arts programs.

~ v1 ~

CONTENTS

Introduction .. 1

Preparing Yourself ... 3

 Set Up a Tracking Document .. 4

 Social Media .. 6

 Artist's Statement .. 7

 Artist Headshot ... 8

 Build a Library of Artwork ... 9

Finding the Art Shows ... 11

 Search for Nearby Galleries .. 12

 Art Organizations .. 13

 Cultural Councils .. 14

 Commercial / Non-Profit Websites 15

 Google Search on "Call for Artists" 16

 Read Resumes of Local Artists 17

 Newspapers ... 18

Entering Art Shows .. 19

 Read the Submission Instructions 20

 Submitting Online vs In Person 21

- Taking Photos of Physical Art ... 23
- Follow Rules for JPG Image Sizes 26
- Shows with Prizes .. 29
- Shows Without Prizes .. 30
- Pricing Your Artwork ... 31
- Describing your Artwork ... 32
- Themed Shows ... 33
- Enter Within the Deadline Time .. 35
- Double Check your Entry .. 36

Dropping Off the Art .. 37
- Wiring .. 38
- Show-Supplied Frames .. 43
- Framing .. 45
- Double-Check the Drop-Off Time 46
- Label Your Work .. 47
- Entry Fee .. 48
- Shipping Your Work ... 49

The Hanging ... 51

- Rail Hanging Systems ... 52
- Nails in Walls ... 56
- The Reception ... 57
 - How to Dress .. 58
 - Food & Drink ... 59
 - How Long to Stay .. 60
- Pick-Up of Art .. 61
 - Write Down the Pick-Up Date ... 62
 - Thank the Art Show Contact .. 63
- Sales at Art Shows ... 65
 - Processing the Sale .. 66
 - Have Receipts and Keep Records .. 67
 - Sales Tax .. 68
 - Income from Sales of Art ... 72
- Winning Prizes at Art Shows ... 73
 - Know the Judge ... 74
 - Frames Do Matter .. 76
 - Clean the Glass .. 77
 - Photos In Focus ... 78

Add Another Dimension ... 81

Think Outside the Box ... 82

Practice, Practice, Practice .. 83

Venture Far From Home ... 85

Be Patient .. 86

Income Tax on Prizes .. 87

Summary .. 89

Glossary ... 90

Dedication .. 93

About the Author ... 94

Free Ebooks ... 97

INTRODUCTION

*"Art washes away from the soul
the dust of everyday life."
-- Pablo Picasso*

Our modern world celebrates the beauty of art! Most people own smartphones which include cameras. Photographers no longer have to deal with expensive film processing. Local malls have art stores filled to the brim with a wide variety of paints, pencils, papers, and supplies which would have boggled the mind of an artist even twenty years ago.

Art is in its renaissance.

This book exists to help those new to the world of art learn about sharing and selling their art. Whether you're enjoying the abilities of your iPhone, exploring the world of acrylic paints, or dabbling in the blues of cyanotypes, we're here to help. There's a wonderful world of art shows out there, and it's just waiting to share your talents.

This book starts from the very beginning. How to find those art shows. What the terms mean. How to enter. How to prepare your art for the show.

The book talks about sales and finances, taxes and record-keeping

And, of course, How to win!

Everything you need to enjoy the wondrous world of art.

All proceeds from sales of this book, in locations where it isn't free as intended (for example in paperback format), support childhood art programs.

PREPARING YOURSELF

Before you start entering art shows, you first need to prepare yourself. It is, after all, you that you will be marketing at art shows.

Here are a few steps to take before you begin with your art show project.

SET UP A TRACKING DOCUMENT

One useful system to set up before you start entering shows is a tracking document. I highly recommend an Excel spreadsheet or Excel-like clone. Anything that you can set up columns and rows in where you can sort them.

The fields you'll want to track are:

- Date
- Show Name
- Artwork Name
- Artwork Size (including frame, if any)
- Submission Price
- Submission Deadline
- Drop-Off Date
- Reception Date
- Pick-Up Date
- Sale Option and Venue Commission
- Status

A key reason you need this is that some shows won't let you enter any pieces more than once. So if you enter your piece "Vision in Blue" to the ACCC Spring show, you can't then re-enter the same piece to their ACCC Fall show. It can get confusing quickly what you have entered to where in the past. A spreadsheet makes that all simple and easy.

It's also very easy to enter a show and completely forget about its pick-up date. Having everything in one place makes that easy to track.

Set this up from the beginning. It'll save you a lot of grief and headaches later on.

That being said, if you're not familiar with Excel and this seems like a headache which might put you off from starting out, go ahead and use a piece of paper for now. It's better to move forward than to get stuck on something like this.

SOCIAL MEDIA

In many art shows you're allowed to list links to your Facebook, Twitter, and other pages as part of your label or documentary information. It's good to set those pages up early.

You may hate Twitter. Heck, you may hate Facebook! Still, these places are tools for marketing. You don't have to love them. It's just quite useful to use them. Create a page on Facebook, Twitter, and perhaps Instagram and others as well. Even if you don't have them all, at least have ONE. It's quite useful to have at least one place to let fans connect with you.

That will serve you well going forward.

ARTIST'S STATEMENT

Writing an artist's statement is not a one-time thing. It's an ongoing project that can change month to month. Think of an artist's statement as a living document. One that describes you for the moment and can easily change next month.

Different art shows will often have different length requirements. Some won't require any at all. It's useful to keep a range of them handy. Sometimes they want just 100 words. Sometimes they want 1000. Start long. Write a complete statement. Then, as needed, create shorter versions. Save them all. You never know when one you wrote last year will be perfect for an upcoming show.

Artist's statements are generally written in the first person – "I enjoy photography because …" Think of it as a conversation between you and the person looking at your piece.

ARTIST HEADSHOT

Artists are notoriously shy about having photos taken. Buckle down and just get it done. Many art shows want to have artist headshots for a variety of reasons – for the brochure, for promotion, and so on.

If you're not comfortable taking a photo of yourself, ask a friend to do it. It doesn't have to be perfect. It just will come in quite handy as you move forward.

BUILD A LIBRARY OF ARTWORK

It perhaps goes without saying that in order to enter an art show you need something to enter.

So build a library of your art works. It's ok if you only have a few to start – that's how we all begin. If these are physical artworks like acrylic paintings or watercolors, get help with taking photos of them. It can be tricky getting the lighting and angle just right to showcase the artwork well.

Make sure your photos don't have any background "clutter" in them. No kitchen tables or cats. The photos should be solely of the artwork in question.

It's also good to have a spreadsheet of your artwork, especially if they are non-photographic. The list would typically include:

- Name
- Creation Date (some shows care about this)
- Size including frame
- Medium (watercolor, acrylic, etc.)
- Location (update when at a show)

FINDING THE ART SHOWS

"To be an artist is to believe in life."
Henry Moore

OK, you've got your art images ready and your tracking spreadsheet. How do you find the art shows to enter?

SEARCH FOR NEARBY GALLERIES

The first step in your search for art shows is to build a list of nearby galleries and museums. I would again do this in a spreadsheet, but any tracking device will do.

For each gallery, list:

- Name
- Town
- Website
- Phone number
- Hours
- Show Types

For show types, the idea is to indicate whether or not they offer open shows to the public. Is this a gallery that only works with its own members? Or is it the type of gallery that, every spring, holds an open photography show that anybody can enter?

This is your base list to work from. If you have galleries on this list that have an open show every quarter, you know to check back every quarter to see what the theme-of-the-season is.

If you can, visit the ones with open shows in person. The more you build relationships with the people, the better your chances are of participating.

ART ORGANIZATIONS

Most regions have at least one or two art organizations operating. I'm fortunate – I live in central Massachusetts and we have quite a few organizations here. I belong to a number of them and there's even more that I don't belong to. The more organizations, the more opportunities.

First, check out the shows that each organization runs. For example, I belong to the Blackstone Valley Art Organization, and they run quite a number of shows each year. It gives me ample opportunities to have my artwork shown, especially around the holidays.

Next, look into the shows that the organizations spread the word about. A watercolor group might not only run their own shows but also inform people about shows for watercolors held in nearby regions.

CULTURAL COUNCILS

Many states have a "cultural council" of some sort – an organization which helps to promote the arts. Those cultural councils often maintain lists of upcoming art shows so that all artists can coordinate what is going on.

So, for example, here is the page for the Massachusetts Cultural Council about art events coming up:

http://artsake.massculturalcouncil.org/blog/artsake/index.php/category/call-to-artists/

Do a search to find a similar listing for where you live.

COMMERCIAL / NON-PROFIT WEBSITES

There are a number of websites out there, both for-profit and non-profit, which list art shows by region. Add those to your bookmark listings and check them regularly. You never know what you might find.

Here's one I use:

http://www.artshow.com/juriedshows/Northeast.html

Even if a show isn't in your region, it might be worth entering if it's on a topic you adore. You could either plan a trip or just ship your artwork to them.

GOOGLE SEARCH ON "CALL FOR ARTISTS"

Yes, it's fairly basic, but it works! The term many art galleries and shows use for their press releases is a "Call for Artists"

Do a search for Call for Artists along with the name of your state or a large city near you. See what comes up.

If you're into a specific type of art, like plastic cameras, then do a search like:

Call for artists plastic cameras

See what comes up. You might find a wonderful show out in San Francisco that you're willing to enter and mail art in to.

READ RESUMES OF LOCAL ARTISTS

Many times, local artists will have websites or social networking pages where they post their resumes and accolades.

Read through those pages.

Look into the shows they have entered and won. Check out upcoming rounds for those shows. Are they ones you'd be interested in entering?

If a local watercolor painter says that they got third prize in the 35th Annual Watercolor Show in Boston, it's likely that this is an ongoing show that will have new options in the coming year. Search them out and take a look.

NEWSPAPERS

I know they may seem quaint, but many associations do still promote their events in newspapers! Grab your local newspaper or read it online.

Even if you just check it once a month, you can still come across interesting local events you never knew about.

In addition, take a look into the listings of upcoming shows at local galleries and museums. Even if you can't enter that particular show, it still gives you a contact to keep an eye on for future calls for artists.

ENTERING ART SHOWS

"Color is my day-long obsession,
joy and torment."
Claude Monet

It is normal to be nervous entering your first art show or two. Take a deep breath. Soon this will become a fun, normal activity!

READ THE SUBMISSION INSTRUCTIONS

I know this might seem like a standard thing to do – but you'd be surprised how many people don't do it! People get disqualified from art shows for all sorts of reasons. If you simply follow the instructions, you're already head-and-shoulders over your competitors!

The key things to look for are:

- Submission Deadline
- Drop-Off Date
- Pick-up Date
- Restrictions on Artwork

Some shows only want artwork created in the past year. Some only want photography. Some require that the finished piece – including frame – is below a certain size.

The more you pay attention to the rules, the greater your chance of being accepted.

SUBMITTING ONLINE VS IN PERSON

Many shows now let you submit your work wholly online – including images of the artwork to be showcased.

Still, there are some shows that require you drive the piece out, in person, so a judge can see the physical piece directly before approving or rejecting the piece. When a judge person or group determines which pieces are included in a show, that is called a *juried* show.

Yes, that physical travel activity can be a royal pain. But those shows do that for a reasonable purpose. Sometimes a photographic version of a piece can look awful because the artist just isn't good with a camera, when the original piece is simply stunning. Bringing the original piece in helps make that clear. The artist can be talented with watercolors without also having to be an expert in taking photography of watercolors.

If the gallery is far away, talk with friends and family to see if anybody else is entering the same show. You can share driving duties so that one person takes pieces out for the judging part of the show.

Note that some shows which have up-front judging will do judging same-day. So you drive your piece out, they give you a yes-or-no, and you either leave the piece with them or take it home again. But other shows have a multi-stage process. Everyone drops off their pieces in a certain date range. The judges make their decisions. Then those who are not accepted in the show have to drive back again to pick their pieces up.

This can mean two long drives for a person who isn't even accepted into the show.

Be aware of those requirements before entering!

TAKING PHOTOS OF PHYSICAL ART

For situations where you are online-submitting a JPG (electronic) image to represent a physical painting or sculpture, it's worth talking specifically about this process.

First, yes, take the absolute best photo you can of that object. Let's use an example of a cyanotype work of art. It's a print made from exposing coated paper to the sun. You want to lie that art flat on the floor. Set up the best lighting you're able to. If you can use natural sunlight, that's generally best. Then get your camera positioned right above it so the image is "square" in your viewfinder. You want to avoid your image being twisted or at angles.

Here's an example. I made a cyanotype on 9 x 12 paper. I laid that cyanotype on a plain background on the floor. I then stood up above it to get a top-down photo of it, so the image would be as "straight-edged" as possible.

You would then trim (or "crop") that image so that only the cyanotype itself was shown in the final JPG. That cyanotype is what you would want the people judging your image to see.

It will be tempting, as part of this process, to "enhance" your final image. You'll be tempted to play with colors, contrast, light and dark, to make that final image "better."

DO NOT DO THIS.

You need that final image to accurately represent the work of art you are bringing in. It must match the painting! If you make a super-saturated version in the JPG, and the committee loves it, and then you bring in the real painting with pale colors, they are not only going to reject the painting for not being what they saw in the JPG but also mark you going forward as someone not to trust.

You need your JPG to be 100% a match to the original painting.

Now, with this being said, if you have problems with lighting and for some reason your photo of the waterfall makes the waterfall green rather than blue, then you CAN fix the photo so that it more accurately matches the painting. So if the photo has a problem it's OK to try to fix it so it is more like the painting.

But other than that, you need that photo to be as perfect a match to the painting (or cyanotype or whatever) as possible. You should never be seeking to enhance the photo.

FOLLOW RULES FOR JPG IMAGE SIZES

If you are submitting JPG electronic images to an online interface, there will undoubtedly be rules stated about the size and naming convention of the images you submit.

For example, one standard requirement is that the image have a resolution of 300 PPI (pixels per inch), have a maximum width or length of 2000 pixels, and have a maximum overall file size of 3MB.

If this all seems like gibberish to you, don't panic! It's really quite straightforward. And now is the time to practice.

Your best bet is to ask around with friends and family to see if someone knows about working with images. That way they can sit down with you and help you learn the basics. Once you learn how this works, it'll become simple fairly quickly.

If there is nobody at all near you who can help, turn to YouTube. There are countless videos that help you, step by step, learn to use whatever graphics program you have to make these changes.

For example, in Photoshop, you simply choose image -> resize -> image size. That lets you change both the resolution (the pixels per inch) as well as the maximum width and length.

Art Shows

As far as file size, when you do your file -> save, you get a slider bar right on the save page which lets you slide the quality levels up or down to impact the overall file size. Just slide that slider bar to a lower quality level until the file size gets to the range you need it to be.

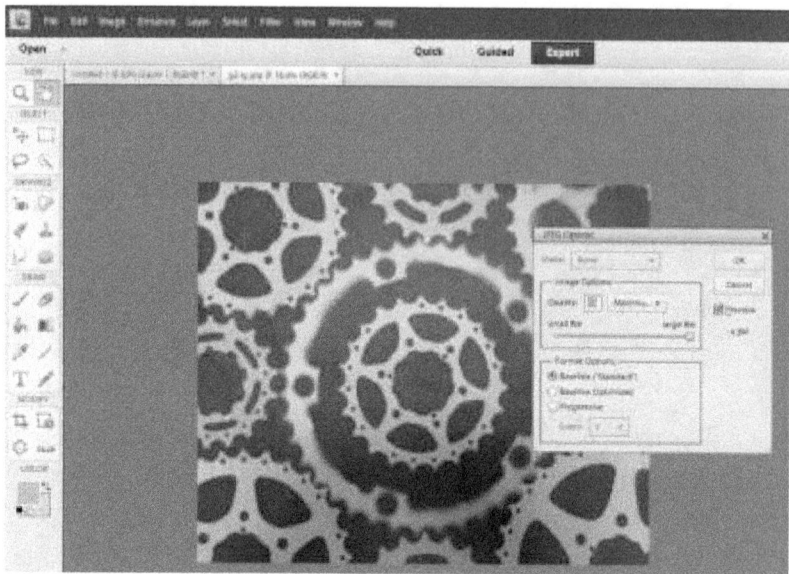

Again, there are step by step instructions like this on YouTube (and in pictorial form on the web) for pretty much every version of every software package you could be using. Just take a look for them and practice. Soon you'll be an expert!

On the file naming side, usually the instructions are straightforward. Something like this:

Name your work Lastname_Firstname_Title.jpg

So in the above case, I would name my work

Shea_Lisa_Gears.jpg

SHOWS WITH PRIZES

Some shows award prizes. These prizes are almost always stated up front, so you know what the prize opportunities are for a given show. Sometimes they are cash prizes. Sometimes they are gift certificates. Often the actual prize amount is based on the number of entries. The more entries (and therefore the more entry fees) the higher the prize value.

It's good to get a sense of what the prize amount is going to be before you enter. This helps you judge the effort of driving and the entry fee against what you might get in return.

SHOWS WITHOUT PRIZES

Many shows without prizes are free to enter. This provides a way for you to get free publicity for your art, and maybe some sales, in exchange for driving your piece out and being without it for a while.

Art shows without prizes can be a great way to spread the word about your efforts and to meet other like-minded artists.

PRICING YOUR ARTWORK

If you are allowed to sell your artwork at this show, give thought to how you're going to price it.

The first thing to consider is how much it cost you to make it. If you're a painter, it's fair to consider the cost of the canvas and the amount of paint you used. If you're a photographer, it's not fair to consider the entire cost of the camera! The camera is not "used up" when you make one photo. The cost needs to be pro-rated across all of its use.

Look at what other items in this show have been priced at in the past. What range is appropriate for this venue?

For example, a photo might sell in a Boston gallery for $300. That same photo might only be able to sell for $100 at a small town craft fair. Give thought to your market.

Also, most venues will charge a commission on the sale. If a venue charges a 20% commission, and you price your work at $100, they will take $20 of that and give you $80.

Finally, depending on where you are selling, there will probably be sales tax involved. Many people price their works to include that sales tax. In Massachusetts, sales tax is 6.25%. For $100 that is $6.25. Be sure to consider that in your pricing calculations. If you are taking the money directly, you will be responsible for that. If the gallery is handling the sales, they will handle that for you.

DESCRIBING YOUR ARTWORK

It's a good idea to look at other art shows – either in person or online – to see how other artists in your field describe their own artwork.

For example, rather than just say "photograph" some photographers will instead say "photograph printed on archival acid-free paper." This matters because a photo printed on regular copy paper would, over time, get brittle and the colors would fade. If you've taken the time to print your photo on something more sturdy, it's worth it to mention it.

Similarly, some photographers boast about their print being made with the *giclée* process. All that means is that an ink jet printer was used. It's a marketing term invented in 1991. It sounds nice, though, so if you or your printer used an ink jet printer, it might be worth using this term.

THEMED SHOWS

Many times, art shows have themes. Sometimes they can be specific like "film photography" or "black and white." Sometimes they can be esoteric like "Ruined" or "Joyful."

Whatever the theme of the show, it's up to you to interpret it. It can be fun to think outside the box. Just don't go TOO far out of the box. If the theme of a show is "greyscale" and you submit a bright, multi-colored rainbow, it's probably not likely that you'll be accepted.

Here's a photo I had accepted into a "toy camera" show. That's a show for plastic "inexpensive" cameras like the Diana and Holga. It got in because not only was it taken with a Holga, thus meeting the baseline rules, but it's also done using slide film developed with cross-processing (different chemicals) which makes the color pop. So there's a bit of extra interest in there for that target audience. It's not just another regular film shot that they've seen hundreds of.

ENTER WITHIN THE DEADLINE TIME

I am notorious for waiting until the last minute to enter shows. My theory is that, since I'm a photographer who takes quite a lot of photos every day, I might come up with something new and exciting even on the last day.

I highly advise not to be like me ☺.

You never know what will happen on that last day. You might get sick. Your internet connection could fail. The website might crash. You might get called away by a family member.

Enter early. Maybe not months early, but at least days early. Get your ducks in line and get that information in. That way you're safe and sound no matter what life throws at you.

DOUBLE CHECK YOUR ENTRY

Your entry is how your art is going to be judged. Double check it.

Look for typos. It would be embarrassing to have a big typo hanging next to your beautiful painting or photograph.

Make sure, when you list the size, that you include the OUTSIDE OF THE FRAME. If you are submitting a photograph that is an 8x10 photograph image, don't say 8x10. Make sure you include that entire outside of the frame it'll be in. The people arranging the art show need to know how much space total your work is going to take up, so they can figure out how much wall space is left for other pieces.

DROPPING OFF THE ART

"An artist never really finishes his work;
he merely abandons it."
-- Paul Valéry

OK, you're ready to bring your artwork in to the gallery, either for them to review it or because they accepted your online submission.

What should you think about before you drop off your art?

WIRING

Most galleries have specific requirements about how a piece must be wired. For example, the Blackstone Valley Art Association requires that all pieces that are submitted to shows be wired. What does that mean?

Let's look at some examples of right and wrong when it comes to wiring.

Triangle – Wrong

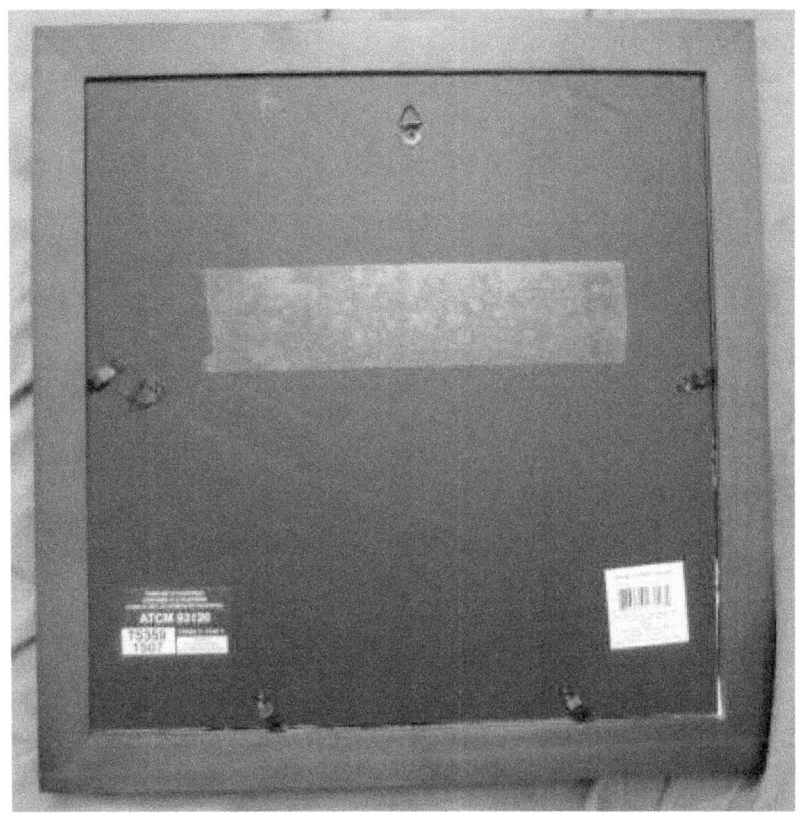

This is the way many inexpensive frames come. With little triangles to hang the artwork by. This just can't be used by most art shows. That tiny triangle won't fit on their hanging system. It can't be adjusted. If all you have is a triangle, you're probably going to need to fix the frame or get a different one.

Check the show's rules. This is not "wired".

Sawtooth – Wrong

That metal ridged hanger at the top of this frame is called a sawtooth frame. It, in theory, lets you slide the piece left or right over a nail to get the frame to hang centered.

Unfortunately, it requires a certain size of nail and it doesn't work at all with many hanging systems.

Most shows won't take this kind of a hanger. If this is what you have, it's time to wire up or find a new frame.

Wired Frame – Correct

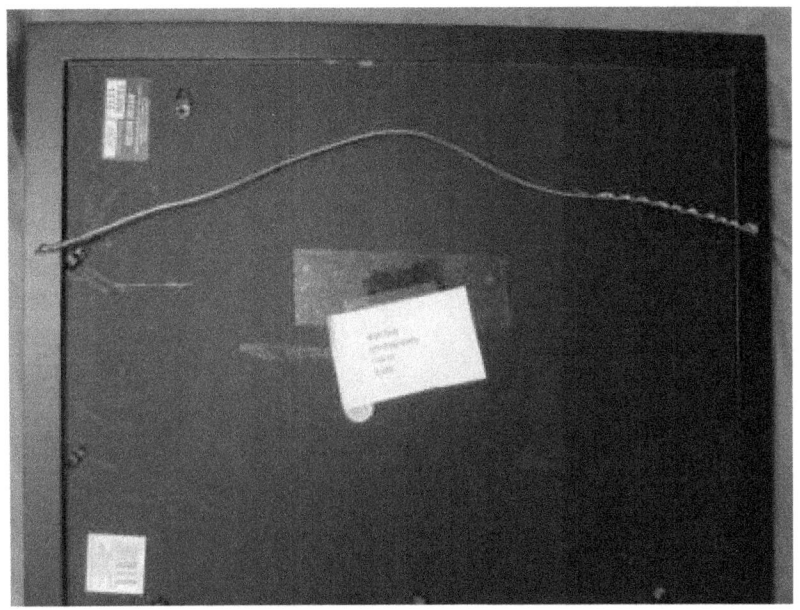

This is what art shows prefer. They want a wire running left-to-right across the back of the frame. You can buy that wire – along with the eye-hooks to connect it to the frame – from most hardware and craft stores.

You want the eye-hooks to go in solidly about $1/3^{rd}$ of the way down the frame. The wire should be slightly loose but it should not be visible off the top of the frame.

Normally what you do is wrap the wire twice through one eye hook, leaving a bit of slack wire. Wind that slack wire around the main wire that is going across to the other side. On the other side, wind the wire through the eye-hook twice. Then

take the remaining slack and again wind it around the main wire. That will hold the wire in place.

You can drill the lead hole for the eye-hook in with a Dremel type of tool.

Make sure the eye hook is long enough to have enough grooves to bite. If only a groove or two gets into the wood it's going to pull right out.

If possible, it's even better to use D-rings. Those lay flat and are more secure.

SHOW-SUPPLIED FRAMES

Some shows, for example the shows held at the Worcester City Hall in Worcester, Massachusetts, require you to use THEIR frames. In this case they will tell you specifically the size of their frames, so you can make sure your art fits within that frame.

For the city hall, the interior of the frame is 16 x 20. The piece can be hung horizontally or vertically, as long as the mat reaches to 16x20. Many people cut their own mat-holes so that the inner hole matches whatever size they wish to print their photo out.

The mat in this case must be white – no other colors are accepted. Also, there needs to be a 16 x 20 foam board behind the print, in order for it to fit securely within the frame.

If you are working with a group that supplies the frame, make sure you know exactly the outer dimensions for that mat, the color of the mat, and whether any backing foam board will be required.

Also, it's a good idea if you're framing in person to bring along both a flat-head and Philips-head screwdriver for the assembling and disassembling of the frame.

If you are shipping your artwork to a show and they will be framing for you, often they will charge you a framing fee. That could still be far cheaper than you buying the frame yourself and paying to ship it to them.

FRAMING

In general, most art shows will require your work to be framed. They consider that this gives your work a "finished" look.

Some art shows are OK with other styles of presentation. Some will accept a canvas-wrap layout, for example.

If your work is not framed, make sure you check ahead of time to ensure it will be all right.

DOUBLE-CHECK THE DROP-OFF TIME

I myself have dropped off pieces late by accident because I mis-read the drop-off time, and missed being judged as a result. I've seen people bring artwork to a show on the reception date, hoping to be hung, when the hanging had happened days in the past.

Make sure you know the drop-off date and time period. Double-check it. Triple-check it. If the date says January 10^{th} from noon to 6 pm, don't expect to drive in at 5:55 pm and be all right. Things happen. It's safest to aim for early to the middle of a period.

If there are multiple days, like January 1-7, aim for the early part of the range. That allows for cars to have issues, human beings to have issues, and so on.

LABEL YOUR WORK

Nearly every show will have some sort of labelling requirements for the pieces submitted. Follow those instructions. Often they will give you a printout to tape to the back. Tape that to the back.

What I do is first put a piece of packing tape on the back of the frame. Then I tape whatever label I have to that packing tape with a piece of regular tape. That way I can take the label on and off without damaging the frame. When I go to a new show I just attach the new label.

If the show does not have any requirements for what goes on the label, I suggest:

- Your Name
- Piece Name
- Piece Medium
- Phone Number
- Email Address
- Price

That covers you for nearly all situations.

If the show's label does NOT have that key information on it, I'd suggest adding a second level which does have these details. That way, if someone does buy your piece, you know that they have your contact info in case of questions.

ENTRY FEE

If you haven't paid the entry fee up front, be sure to bring cash or check along with you to pay the fee when you drop the piece off.

A few places do take credit cards, but it's better to be prepared that they won't be able to.

SHIPPING YOUR WORK

If you are shipping your work to a show, make sure you do everything you can to ship it safely. Use padding. Cardboard corners on the edges of the frame. Some shows require you to use an acrylic glaze over your piece to help protect it from harm.

Do some research on how to ship pieces of your type, to see how others handle this challenge.

Also, don't forget about return shipping. Make sure your box can be re-used and that you supply money or postage for that return trip.

THE HANGING

*"The object isn't to make art,
it's to be in that wonderful state
which makes art inevitable."*
-- Robert Henri

The word "hanging" has a negative connotation for most. But in the art world, it's what one calls the act of putting art on the wall.

Here are the two common types of hangings done. For some shows the organizers will do the hanging on their own and just expect you to show up for the reception. For other shows, though, the organizers ask that the artists come help with the hanging process. So it's good to know how they work.

RAIL HANGING SYSTEMS

Many modern galleries use a rail-based hanging system. These exist at many libraries and galleries in Massachusetts because it saves greatly on nail-holes in the wall.

How this works is a metal rail is installed along the top edge of the wall. From this rail hang down moveable plastic strips. Metal hooks attach to this strip and can be slid up and down. Since you can slide the strip left to right, and the hook up and down, it means that images can be hung just about anywhere along that wall.

Here's an image of my waterfall image being shown at the Morini Gallery in Mansfield, using a rail hanging system.

To help with this type of hanging is quite easy. You just slide the plastic strip left or right until it's in the position desired. Then you slide the metal hanger up or down on the strip until it's at a good height. You use a tool to tighten that hanger in place and you're done.

Panels with Metal Strips

This is a related hanging system that is used with panels. A metal hook has a U-shape at the top of it so it hangs over the top of the panel. The rest of the metal strip stretches down the front part of the panel. There are extension pieces which can hook onto the bottom of that first piece to allow pictures to be hung beneath each other.

These metal hooks and extension pieces have holes drilled at regular intervals down their length.

One uses a S-curve metal piece to stick into a hole. The other side of the S-curve is what one hangs the wire on the back of the painting or photograph onto.

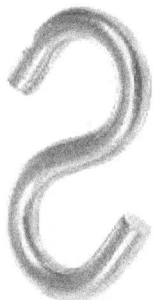

This is also fairly straightforward in terms of arranging it. You just slide that long metal piece left or right to get it centered on the panel. Then you stick the S-curve piece into whichever hole is about at the height you wish to hang the painting at. It's not precise, but it works.

NAILS IN WALLS

The original method of hanging items was, of course, simply hammering nails into walls. This lets you put that nail exactly where you want it. That is how Premier Image Gallery works, for example. Here's one of my photos in a show there.

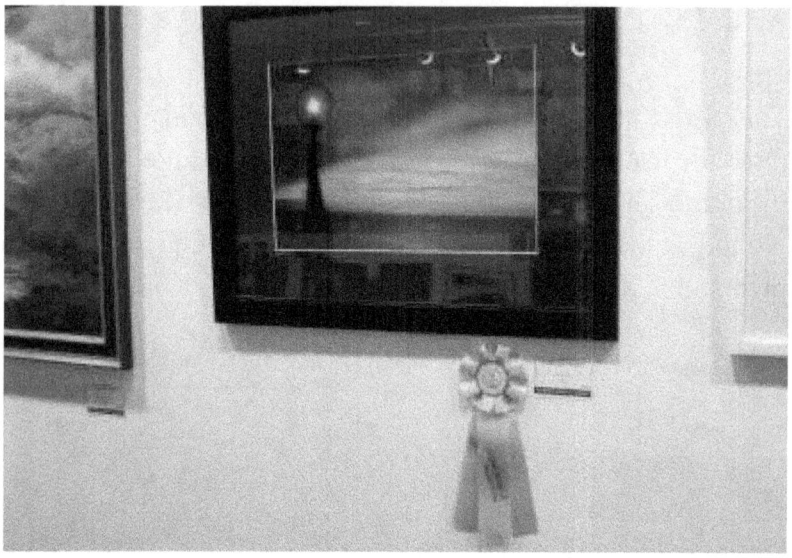

I'm sure you can imagine the downside here. Hundreds of holes. You have to patch them up and repaint after every show. So this is quite time-intensive and labor-intensive.

Still, it means there are no strips showing anywhere. Some prefer that clean look to a show. If you're going to a show that is being done this way, it's good to bring an extra hammer. Usually the wall is all painted for you and they'll have the nails and hooks ready to go.

THE RECEPTION

*"Creativity is allowing yourself to make mistakes.
Art is knowing which ones to keep."*
-- Scott Adams

Nearly every art show will have a reception of some sort to draw in visitors and to allow those visitors to meet with the artists. Usually it's a prime opportunity for sales to occur.

Here are some things to know about the reception.

HOW TO DRESS

Different organizations have different ways of dressing. The best way to know is to look through photos of past events. Do people tend to dress up? Do they wear jeans and sweatshirts? In general, aim for a spot in the middle of what they do, if you want to fit in with the crowd.

Of course, you're an artist. If you don't care, then just wear whatever you want. Celebrate your individuality!

FOOD & DRINK

Different groups have different policies about food and drink. Some supply all the food and drink through a high-end catering company so you can eat a full meal there. Others as the artists to bring in supplies for a pot-luck kind of feel.

Check up front to see if you'll be expected to bring anything or if there'll be food present there.

HOW LONG TO STAY

You should never be required to attend an event or to stay for a certain amount of time.

That being said, if there are prizes awarded, it's usually a good idea to stay around for the prize part, just in case you won. Usually that's about half-way through the stated reception period to allow everyone to get there.

Many people leave after those awards are done. That being said, especially if the food and wine is flowing, some people like to stay until the very last minute.

It's up to you!

PICK-UP OF ART

*"It's not what you look at that matters,
it's what you see."*
Henry David Thoreau

When the show is complete, make sure you get your artwork! This might seem common sense, but it's amazing how many artists lose track of picking up their artwork.

WRITE DOWN THE PICK-UP DATE

The first key, of course, is to know WHEN the pickup date is. Write it in your spreadsheet of art shows. Also, write it in your spreadsheet of your individual pieces of art.

Finally, write it on your actual calendar.

Check those three lists occasionally. Make sure you haven't forgotten about a piece somewhere.

THANK THE ART SHOW CONTACT

Whoever you did the show with, thank them for the opportunity to be in the show.

The better relationships you build with the art world, the better it will serve your art dreams going forward!

SALES AT ART SHOWS

"Every child is an artist.
The problem is how to remain an artist once he grows up."
-- Pablo Picasso

Some artists enter shows just for winning ribbons and having fun. Other artists are hoping for a few sales.

Here are some things to keep in mind when it comes to art sales.

PROCESSING THE SALE

A sale involves you giving a person an item in return, usually, for money.

If the gallery or venue handles the sale and then gives you your share of the sale, you're all set. They'll handle credit cards and checks and so on.

If the arrangement is that you personally handle the transaction, I highly recommend getting a Square device. You can learn about them here:

https://squareup.com/reader

This plugs into pretty much any smartphone and allows you to take credit cards.

HAVE RECEIPTS AND KEEP RECORDS

It's a good idea to have one of those multi-part receipt books if you do your own sales. That way you have a receipt to give to the buyer and also keep a record of what you've sold, for your own purposes.

I also highly recommend having a (guess what?) spreadsheet for sales. Include:

- Date of Sale
- Title of piece
- Approx. size of piece
- Amount sold for
- Venue

This is good for tax reasons, for tracking reasons ("where did that painting I made go to?), and also for planning reasons. If you look back and realize that you do great on sales of flowers in the spring months, you can plan ahead for next year.

SALES TAX

If you are doing a sale in a state that requires sales tax, and you handle the transaction personally, then you are going to owe that sales tax.

I'll give the examples for Massachusetts, where I live, but you'll want to research this same information for wherever you live.

The sales tax rate in Massachusetts is 6.25%. This applies to all tangible property. Art – including paintings, photographs, and sculptures – definitely falls into this category. Even if you just sell one painting or photograph across a year you are required to transmit the owed sales tax to the State of Massachusetts for that sale. Even if you sell just one bin-art print for $20, you are responsible for submitting the sales tax.

Massachusetts Sales Tax Guide

Applying for a Vendor License
If you ever sell at festivals or shows where you have a table set up for you then you technically need a vendor license. Even if you have a bin out with your work that would apply. If you ever work with businesses paying you it's a good idea to have that vendor license. In any case, it's easy and free to get the license so it's well worth it. You then get an online interface to file your sales tax.

The place to get your Vendor ID and to then file your sales tax numbers is here –

https://mtc.dor.state.ma.us/mtc/_/

It's all straightforward and online. You report how much you sold in total for the time period (usually the previous year). You figure out what the sales tax on those sales would be. You pay it and you're done.

If the only time you sell art is a one-off situation where a person emails you directly and asks to buy something, then you can go with filing your sales tax on your normal taxes each April. You wouldn't need a vendor license in that situation.

Sales < $1600/yr
If, across an entire year, you only owe $100 or less from sales tax, you only need to file annually. That would be from earnings of $1,600. If that is all you owe, you can do that on your normal tax form in April. If you have a vendor license, you file that payment amount online once a year.

From the Mass.Gov page:
Businesses and individuals incurring use tax liabilities [under $1600/yr] who are not registered vendors may file Form ST-10 (Business Use Tax Return) or Form ST-11 (Individual Use Tax Return). Both returns are due annually by April 15. Alternatively, individuals may report and pay any Massachusetts use tax due on their personal income tax return, Massachusetts Resident Tax Return (Form 1) or Form 1-NR/PY for part-year residents, or WebFile for Income.

Sales > $1600/yr

If you owe $101 to $1200 a year you need to file quarterly. If you owe $1,201 or more in a year you have to file monthly. Those filings can be done online. Details –

Sales Tax Filing Guidelines

There is never a situation where you earn money from a sale and you do not incur a tax burden for it. If you are paid money for the sale of artwork you owe sales tax on that sale. This includes photographs, paintings, and prints. That is the bottom line of Massachusetts law.

Note that, as an artist, you can claim income tax credit for the items you use as part of creating your art. You can get income tax credit for your brushes, paints, cameras, ink, paper, and everything else you use to create your final product. You get credit for those items in the year that you purchase them. These purchases can easily offset the burden of your tax payment. However, you have to make sure you file for those expenses. You are the Sole Proprietor of your artistic small business. Ideally you want to set up a separate, free checking account for the artistic projects and ensure those art-related incomes and expenses are tracked separately. That makes the process simple and easy.

Important – from the Massachusetts tax page: *Willful evasion of taxes is a felony punishable by a fine up to $100,000 for individuals or $500,000 for corporations and/or imprisonment for up to five years. Willful failure to collect and pay over taxes*

is also a felony and is punishable by a fine up to $10,000 and/or imprisonment for up to five years.

The bottom line is – pay your sales tax on things you sell! Then properly deduct the cost of your raw materials and supplies on your income tax each year, to offset that sale. If you maintain a separate account it's quite straightforward to see at a glance exactly what you've earned and spent in a given year and handle the taxes based on that.

I highly recommend you set up an Excel Spreadsheet or notebook or SOMETHING at the beginning of the year. Each time you make a sale, jot a note of what you sold, where, and for how much. That makes the end-of-year reporting just so much easier.

INCOME FROM SALES OF ART

OK, you've properly paid the sales tax to the government for the sale of your painting or photograph. Let's say, just to make things simple, that you sold a $100 painting and in your location that means you gave the government $10 as their sales tax share. You kept $90.

That $90 is income.

And, yes, you need to pay income tax on that $90.

If you are bringing in money by selling items, that income becomes part of your income tax. It all gets counted on your income tax form.

Note that, since it's income, this means that you can tax deduct money you spent in order to earn that income. That means that the cost of your brushes, your paper and canvas, your easel, your camera lens, etc. etc. is now all also tax deductible, too. It's the money you spent on supplies in order to earn you that income.

Your art classes and your art organization memberships are tax deductible.

Talk with someone who is knowledgeable about doing this sort of tax work so that you get it right for the first time you do it. Once you get the hang of it, it will be second nature, but it's good to have a guiding hand the first pass through.

WINNING PRIZES AT ART SHOWS

*"Everything has its beauty,
but not everyone sees it."
-- Andy Warhol*

You might think the judging at an art show is straightforward. One piece is made by Leonardo Da Vinci. It wins. End of story.

Usually it's not quite that simple.

So here's the part you've really been waiting for – some tips on how to win!

KNOW THE JUDGE

Every judge is different. Every judge has their own personal preference. Heck, every gallery has their own style, too. So whether you're submitting to a gallery owner or to a judge of a show, the key is to know who is going to do that judging.

Let's say it's someone who specializes in flower paintings. They have seen thousands and thousands of flower paintings in their life. They have probably seen some of the best flower paintings on the planet and studied them in detail.

Probably not a good idea to give them a flower painting. Unless, of course, you are an absolute expert in flowers, in which case this could be your opportunity to really shine.

Instead, give them something that catches their eye and makes them think "Wow!" If they love flowers and landscapes, that might be a quiet cottage scene. Maybe a serene meadow. If they're a quiet-flower type, they might shy away if instead you give them a gritty barbed-wire-strangling-a-teddy-bear image.

Of course, you never know, but we're playing the odds here.

Learn as much as you can about the judge and the gallery.

There was one time I was racing to submit to a gallery show and didn't do research on the gallery. The theme was 'homes' and I submitted some edgy black-and-white images I'd taken that I really loved.

When I researched the gallery the next day, I discovered they loved to run brightly colored, happy images of seashore cottages with roses tumbling out the windows.

Needless to say, my edgy images weren't chosen.

But there have certainly been other times where I looked into who the judge was going to be for a show, selected images I thought would work well for them, and come home with ribbons.

Think about your audience.

Here's just a few components that judges have said they look for when evaluating art at an art show:

- Color balance
- Subject Matter
- Composition
- Technical skill
- Telling of a Story
- Overall Presentation

FRAMES DO MATTER

You might think that frames just hold up the image – but they really do matter. If you have a fantastically done watercolor with precise detail, and the frame is all chipped and worn, many judges will be impacted by that. To them it shows a lack of care. A lack of attention to detail.

This is one reason to take good care of your frames. Don't throw away that cardboard box or corners that they came in. Store your frames carefully within that protective cardboard. Transport them with care. Use a painting carrier (a vinyl or canvas tote bag made for artwork) if you can. I use old towels and lay a towel between every painting or photo. That way each one is nestled in protective softness.

When you lean frames, never lean two frames face-to-face where they can scratch each other. Don't lean the back of one frame with its wires and eye-hole-screws against the front of another frame.

This isn't to say that you have to pay hundreds of dollars to a frame shop to professionally frame your image. Just, if you're going to buy an inexpensive frame, look through the entire pile of them to find the most perfect one you can. Don't take whatever one is in front of the stack just because it's easy. And then take good care of it.

CLEAN THE GLASS

This goes with the frame comment. If you have glass in front of your image, thoroughly clean the inside before you assemble the work. Bring glass cleaner with you to the show when you drop off and make sure you give it a final clean before handing it over.

Often the show runners will do a final pass after everything is hung. If not, I've been known to have the glass cleaner in the car – or a portable pocket-style one – and give an image a final wipe-off at the show, if someone has gotten big fingerprints on it.

You could think that a judge could completely ignore issues like that, but it's human nature. It does make an impact.

PHOTOS IN FOCUS

I'm not talking about *bokeh*, which is where the back part of a photographic image is nicely fuzzy so you can pay attention to the main subject:

What I mean is that the subject of the image itself needs to be in focus.

Especially with cell phone cameras, there can be a lot of hand shake involved. And while it might seem minor, it is a flaw that many judges will penalize you for. If you're going to win a prize, they want to see an image that is as perfect as it can be.

And hand-shake (camera shake), unless it's an avant-garde abstract, is generally not considered a good thing.

Here's a photo I submitted to a "street photography" show. The reviewer greatly enjoyed the subject matter, the arrangement, and so on. But I was knocked out because the main subject (the Roma woman) was not in perfect focus.

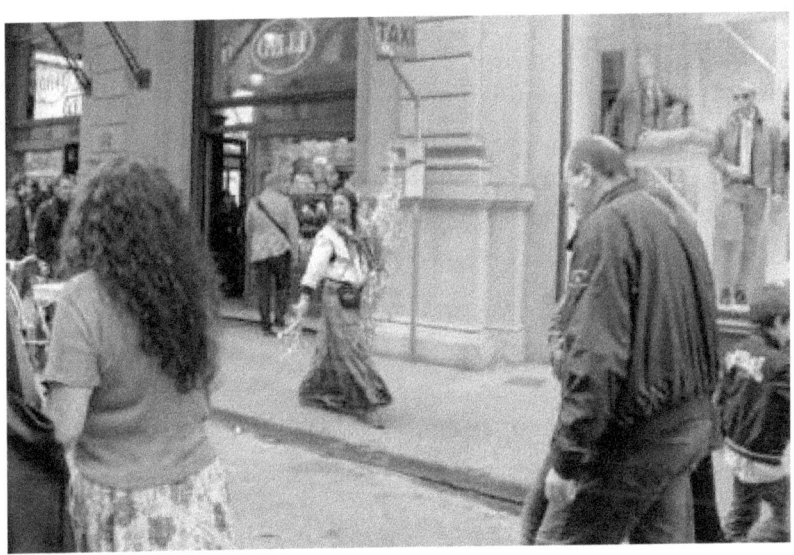

You might say, isn't it a subtle issue? Isn't she close enough to in focus? But it isn't. If you don't have that crisp focus on what you want the eye to be drawn to, then the rest doesn't have that foundation to stand on.

This might be an issue that the average person doesn't notice. If I asked ten friends what they thought of this image, they might love it. Judges are paying more attention to those details. Try seeking out people who are experienced in your particular field and asking them for constructive criticism. Don't just ask,

"Do you like this?" Ask them, "How could I make this better the next time?" And then see what they say.

If you do consistently have issues with shaking hands, look into camera options that can help with this. My own hands shake. I used to have all sorts of problems with this. The solution was to buy cameras that specifically helped stabilize against shaky hands. I use a Canon S100 for example for my point-and-shoot work. It's made a big difference in the quality level of my images. Add the hand shake / camera shake criteria to your own search for camera options.

ADD ANOTHER DIMENSION

For one photography show, I submitted an image of a seashell with the title of "Looking Inside".

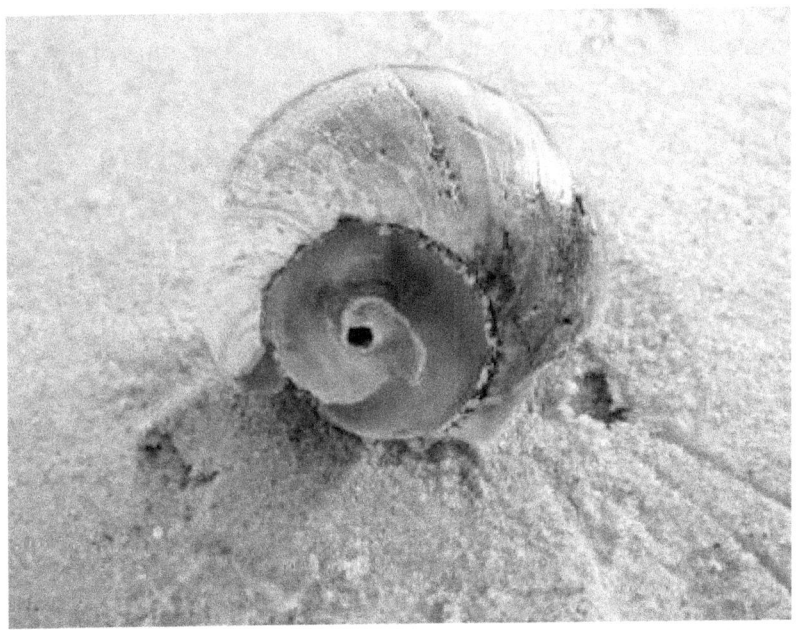

The judge liked it. He said a reason he gave this a ribbon was that yes, the viewer was looking inside the seashell. But with the seashell resembling an eye with a pupil, it was almost as if the seashell was looking inside us. There were layers of meaning to the image.

Think about how your image could have layers. Could your title and/or description add to those layers?

THINK OUTSIDE THE BOX

Sometimes judges have seen far too many "lone flower" and "quiet brook" and so on. Give them something outside the box. Remember to keep it in line with what the judge is willing to consider, and what the gallery is willing to show, but within that, play with the edges.

This piece won a ribbon because the judge felt it was unusual and powerful. It inspired thought.

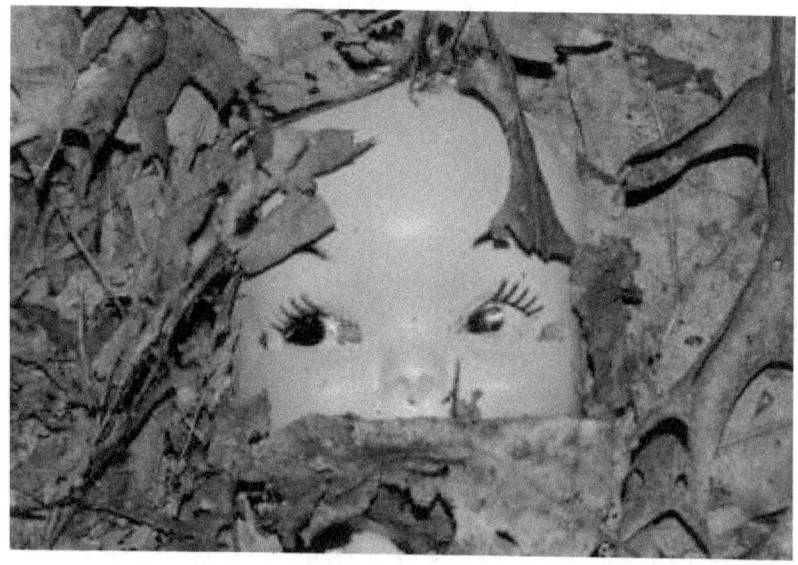

PRACTICE, PRACTICE, PRACTICE

There is, of course, still the caveat that a beautifully executed piece has a great deal of weight behind it. A painting done with exquisite brushwork and colors is going to command attention. A photo of a stunning scene, especially one that isn't seen normally in an area, is going to catch the eye.

Here's a photo that my boyfriend, Bob See, took of a nearby gazebo during the Christmas celebrations.

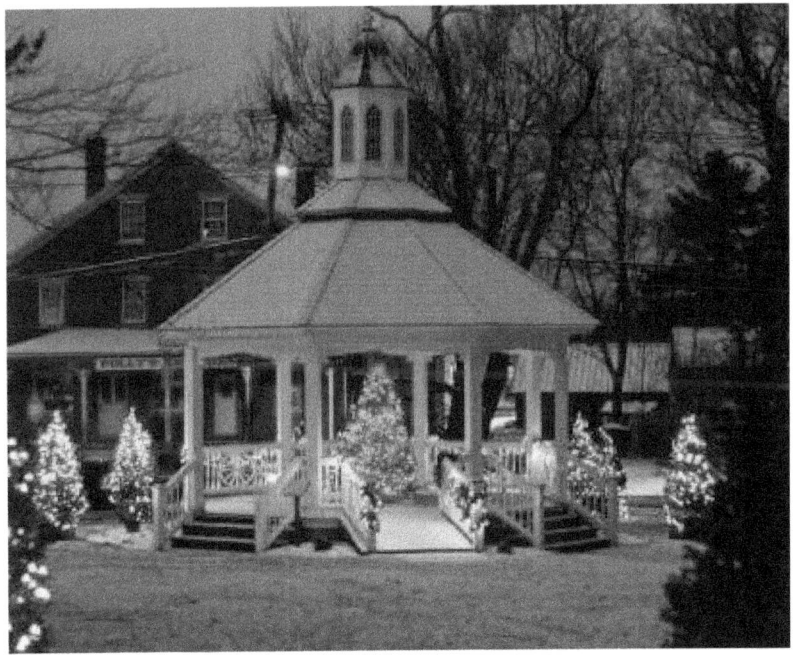

He has sold many copies of this, won awards, and won placement in a regional calendar contest. The contest judges said as soon as they saw that image that they knew they had

their December image. The combination of the deep blue against the glow of the lights drew them in.

VENTURE FAR FROM HOME

A local Massachusetts gallery did a show to celebrate the National Parks birthday. They got a number of submissions from local New England parks, which is to be expected for this region. My boyfriend submitted a photo we'd taken at the Saguaro National Park in Arizona, and it was accepted.

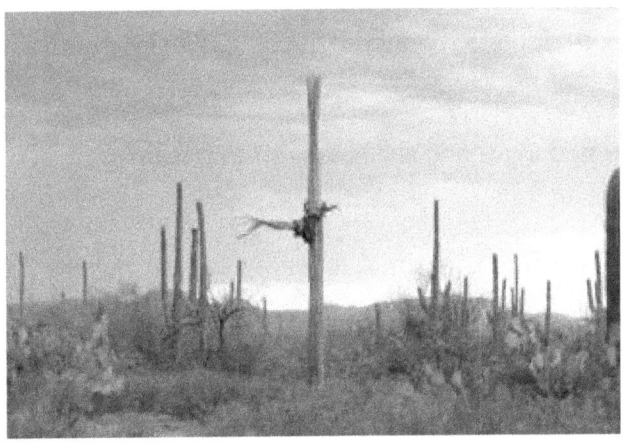

Yes, the photo itself is lovely, but it also got additional boost by being something separate from the other pieces being submitted. If there were twenty items submitted representing the Cape Cod Seashore and only one representing Arizona, then the Arizona one is going to get some advantage over the nineteen "extra" Cape Cod images in the entry pile.

BE PATIENT

You never quite know (unless you have the benefit of feedback) why some things were chosen and others weren't. Maybe the judge had already selected eighty meadows over the past six months and just wanted to try something new. So your meadow painting came at the wrong time. Maybe you chose to paint a seagull and it just so happened that the world expert in seagull paintings happened to submit a seagull painting to that same show.

Maybe you painted a girl and she looks just like the evil ex of the judge.

There are always going to be times that life goes left rather than right. Just accept it, practice some more, and move forward!

INCOME TAX ON PRIZES

It's worth noting that money given to you by an organization is income. Yes, it's winnings – and the government definitely taxes winnings. So you'll want to track your prizes you've won in order to declare them on your taxes.

Note that this isn't all bad. If you are making money from your art it means you can tax deduct the money you spent in order to then earn this money. So you can tax deduct your paints, your brushes, your camera lenses, your classes, your membership fees to local art organizations, and so on. All of that is part of what you spent in order to be able to earn the money you do from the prizes (and sales).

If you haven't done this sort of deduction before, it's a good idea to talk with someone who understands the laws in your area to give you a hand the first time through. But in general it's quite straightforward. You keep track of the money you spend on your art projects. You keep track of the money you earn from your art projects (via prizes and sales). The government then cares if you ended up making an overall net profit at the end of the year.

SUMMARY

Art shows can be a great way to meet other artists, gain exposure for your work, earn some prizes, make some sales, and have fun.

Enjoy the world of art!

All proceeds from sales of this book, in locations where it isn't free as intended (for example in paperback format), support childhood art programs.

Feel free to contact me with any questions or suggestions!

GLOSSARY

Acid-Free Paper – If you painted or printed a photograph on regular copy paper, over time that paper would get brittle. The colors would fade. Acid-free paper helps preserve the image for longer.

Bokeh – The style of photography where the background is gently fuzzy in order to let the viewer focus on the foreground subject.

Giclée – Anything printed with an ink jet printer.

Hanging – The word seems fraught with emotion, but really all it means is the act of putting nails into walls (or sliding a hanging strap into place) and then putting paintings and photos onto those nails and hooks. One will often see in art show descriptions something similar to: "the hanging will be Thursday night and the show opens on Friday."

Juried – This term can have multiple meanings. In some cases it means all entries to a show passed through a jury before they were accepted. Only the pieces judged "good enough" are allowed to hang in the show. In other cases the term juried means that the show had prizes awarded. Anybody could enter and participate, and only some of the participants won prizes.

Mat – the flat usually single-colored piece of thick paper that edges a photo or work of art. Part of its purpose is to highlight the art. Another part is to keep the photo or art from touching the glass.

Opening – a public, organized event to showcase the art. There is often food and drink available at these.

Painting Carrier – sometimes called a *portfolio*, this canvas or vinyl bag is like a rectangular tote bag which is designed for carrying paintings or photos safely.

Wired – the back of the frame needs a piece of wire running horizontally to hang the piece by.

Thank you for reading this *Art Shows* book! I hope I helped you along your way to a creative new hobby!

If you enjoyed this book, please leave feedback! All proceeds benefit children's art programs.

You can also post Goodreads and any other systems you use. Together we can help make a difference!

Be sure to sign up for my free newsletter! You'll get alerts of free books, discounts, and new releases. I run my own newsletter server – nobody else will ever see your email address. I promise!

http://www.lisashea.com/lisabase/subscribe.html

DEDICATION

To the Blackstone Valley Art Association who encourages and inspires me daily. Specific thanks go to Dennis Smith, Bob Evans, Carol Frieswick, and Mike Zeis for their helpful suggestions.

To my boyfriend, who encourages me in all of my dreams.

Most of all, to my loyal fans on GoodReads, Facebook, Twitter, Google+, and other systems who encourage me. Thank you so much for your enthusiasm!

ABOUT THE AUTHOR

I discovered at an early age that I loved a variety of creative arenas. I photographed everything I saw. I scribbled on notepads. I folded origami out of receipts. Rides in busses and cars would become long brainstorming sessions for epic sagas.

As I've traveled to different parts of the world, from the misty jungles of Costa Rica to the dark-soil farmlands of Ukraine, I've become even more aware of the wide range of the human condition. So many people feel trapped in tin-roof shacks or collapsing farmhouses because that is all they know. Women stay with battering husbands because life in the outside world seems beyond their ability to cope. Because of that, I donate much of my profits to charity and strive to have my art be a vehicle for change. Sometimes I take a strong political stance, seeking to showcase a situation that is in need of change. In many other cases I strive to create a sense of optimism; a sense that, with effort and perseverance, a better outcome could result.

One of my central themes is the embracing of serenity and peace. So many times precious energy is squandered on stress, guilt, or wallowing in a past which cannot be changed. The more we can find a sense of peace within us, and cultivate our energy to use in a focused manner, the more we can achieve our goals and dreams. This is valuable not only for us directly, but also for all of those around us who we wish to help and support. This theme especially shines through my soul in my many photographs of quiet, natural scenes.

Most of all, I enthusiastically strive to learn and grow every day. I am continually exploring new techniques, researching new styles, and extolling the diversity which is our world.

I actively embrace social networking and would love to talk with fellow artists and fans about the world of art. I am inspired and awed every day by what our world has to offer us.

Please visit the following pages for news about free books, discounted releases, and new launches. Feel free to post questions there – I strive to answer within a day!

Facebook:
https://www.facebook.com/LisaSheaAuthor

Twitter:
https://twitter.com/LisaSheaAuthor

Google+:
https://plus.google.com/+LisaSheaAuthor/posts

GoodReads:
https://www.goodreads.com/lisashea/

Blog:
http://www.lisashea.com/lisabase/blog/

Newsletter:
http://www.lisashea.com/lisabase/subscribe.html

Share the news – we all want to enjoy interesting novels!

FREE EBOOKS

Here's my library of free books. They should be available for free on all platforms. Enjoy!

Art Shows

Art Shows

www.ingramcontent.com/pod-product-compliance
Lightning Source LLC
Chambersburg PA
CBHW070047210526
45170CB00012B/610